Y0-EBB-557

TANGO

The Rhythm and Movement
of BUENOS AIRES

with photographs by
Jim Zimmermann,
Paula Oudmann
and Oriana Eliçabe

Copyright © 2005 by edel CLASSICS GmbH, Hamburg / Germany
Please see index for individual photographic copyrights
Please see tracklist credits for music copyrights

All rights reserved. No part of the publication may be reproduced in any
manner whatsoever without written permission from the publisher.

ISBN 3-937406-15-8

Editorial direction by Lori Münz / edel CLASSICS GmbH
Graphic design by Anja Steidinger

Produced by optimal media production GmbH, Röbel / Germany
Printed and manufactured in Germany
EarBooks is a division of edel CLASSICS GmbH
For more information about EarBooks please visit: www.earbooks.net

Tango was born to be danced.

Tango from Rio de la Plata, with Buenos Aires and Montevideo on it's banks, is known as "Tango Argentino". It refuses all rationality; denies competitive assessment; and thwarts athletic efficiency. When the stars of the international Tango scene have finished their performances and mingle with dancing admirers, it is difficult to discern the professionals from their audience. This is the genius and the unique quality of Tango: the willingness to improvise. The dance's exuberant melancholy is indifferent to youth and age and holds boundless tolerance towards both brilliant skill and loving dilettantism.

The images of dancing couples bear no trace of Tango's origins in seedy waterfront barrios. A hundred years have come and gone since homesick migrant workers' heartbreak and hard-luck melded with traditions from foreign lands to create a new rhythm and a convivial dance form. Tango is moving more people onto the dance floor and into the concert halls than ever before. It has become a cultural entity in it's own right - ever changing, but never losing momentum.

The Photographers
With his photographs, Jim Zimmermann attempts the impossible: to capture the precise moment of intimate dialogue between the musicians, the dancers and their audience – that fraction of a second in which the show is forgotten and the essence of the dance resounds. Perhaps it is an illusion, but if so, it is one to savor forever. Zimmermann photographs dance performances at Tango festivals and in "Milongas", the clubs where enthusiasts meet. He forgoes flash photography, which might destroy the couple's rhythmic bond. The camera follows the music and the movement. If favor smiles, the dancer's inner intensity is preserved on film. Oriana Eliçabe, a young Argentine photographer, contributes a view to the reality of Buenos Aires as it enters the 21st Century, while Paula Oudmann's images reveal the beautiful colors and compositions which emerge when weather and time lay their kind patina on Argentina's architectural treasures.

FRUTAS y VERDURAS
SELECCIONADAS

FRUTAS

VERDURAS

799

DECOMISOS

FANTASIAS

ELECTRICIDAD

PAPELERIA

JUGUETES

si si

S MEJORES
ETRAS
DE
ANGO

ía de doscientas cincuenta
cada una con su historia

elección, prólogo y notas
or Ángel Benedetti

Seix Barral

El Tango

Fernando O. Assunçã

y sus circunstancias

El Ateneo

TANGO
De la mala vida a Gardel

CARGA y RECAMBIO de ENCENDEDORES

JUGUETES NOVEDADES ART. FOTOGRAFICOS

CI GA RRI LLOS

GO LO SI NAS

SOU VE NIRS

DAMA HOMBR NIÑO

REVISTA DE LAS INDIAS

CD 1

MUSICAS DE NOCHE

01 Gallo Ciego 3:43
(Agostin Bardi) Ricordi Americana

02 La Casita de mis Viejos 4:54
(Juan Carlos Cobian, Enrique Cadicamo) Ricordi Americana

03 Che, Buenos Aires 3:37
(Raul Garello) Relay Ediciones

04 C.T.V. 3:21
(Agostin Bardi) Ricordi Americana

05 Anoche 3:50
(Armando Pontier, Catulo Castillo) Acorde Ediciones Musicales

06 La Clavada 2:49
(Ernesto Zambonini) Ricordi Americana B.A.

07 Quejas de Bandoneón 2:48
(Juan de Dios Filiberto) Pirovano Editorial Musical

08 Cafe "La Humedad" 3:19
(Cacho Castaña) Editorial Warner

09 El Pollo Ricardo 2:32
(Luis Alberto Fernandez) Emlasa Editorial Musical Latina

10 Nocturna 4:14
(Julián Plaza) Julio Korn Editorial Musical

11 Rey de Copas 2:44
(Andrés Linetzky) SADAIC

12 Canaro en Paris 3:34
(Juan Caldarella, A. Scarpino) Record Editorial Musical

13 Como dos extraños 3:01
(Pedro Laurenz, Juan Maria Contursi) Editorial Musical Korn Intersongs SAIC

14 La Cautiva 2:36
(Carlos Vicente Geroni Flores) Editorial A. Perrotta

15 Un domingo siete 2:10
(Andrés Linetzky) SADAIC

VALE TANGO
Andrés Linetzky / piano
Luciano Sciaretta / bandoneón
Alejandro Schaikis / violin
Patricio Cotella / bass
Hugo Silva / vocals

This recording was made during the concert series „Musique de Nuit invite Winter & Winter", Bordeaux, November 2001 through December 2002.
A Production of Winter & Winter, Producer: Stefan Winter
(P) 2002 Winter & Winter, München
With kind permission of Winter & Winter, München

CD 2

TANGO ALLA BAILA

01 Felicia 1:57
(Enrique Saborido) Pirovano Editorial Musical

02 Por tu Culpa 3:20
(Lila Horovitz) Copyright Controlled

03 La Mariposa 3:07
(Pedro Maffía) Record Editorial Musical

04 Garúa 3:07
(Aníbal Troilo) Julio Korn Editorial Musical

05 El Marne 3:44
(Eduardo Arolas) Ricordi Americana

06 El Amanecer 2:54
(Roberto Firpo) Ricordi Americana

07 Comme il faut 2:45
(Eduardo Arolas) Ricordi Editorial Americana Comercial

08 Bahia Blanca 3:14
(Carlos di Sarli) Peer Music Argentina

09 Danzarin 3:31
(Julián Plaza) Julio Korn Editorial Musical

10 Pulentosa Baby 3:00
(Victorio Pujía) Copyright Controlled

11 El Once 2:56
(Osvaldo Fresedo) Edicion Musical Buenos Aires

12 Tiempos Viejos 3:13
(Francisco Canaro) Editorial Musical Dirovano

13 Pobre Pibe 3:13
(Andrés Linetzky) Copyright Controlled

14 El Monito 2:52
(Julio de Caro, Julio Garzon) Ricordi Americana

15 El Porteñito (Milonga) 2:50
(Anger Villoldo) Universal Produc. Mus.

16 Ventarrón 2:16
(Pedro Maffía) Copyright Controlled

17 Romance de barrio 2:27
(Aníbal Troilo) Aura Editorial

18 Pumpa 2:56
(Rodolfo Mederos) Melograf s.r.l.

TANGATA REA
Lila Horovitz / double bass
Luis Longhi / bandoneón
Paulina Fain / transverse flute
Victorio Pujia / guitar
Andrés Linetzky / piano

Digital live recording at Club del Vino, Buenos Aires, Argentina, November 19, 20 & 21 1997
A Production of Winter & Winter, Producer: Stefan Winter
(P) 1998 Winter & Winter, München
With kind permission of Winter & Winter, München

CD 3

¡TANGO VIVO! NOCHES DE BUENOS AIRES

01 El Irresistible (L.Logatti) Julio Korn Ed. Mus. 1:01
Fortina (mechanical harmonium)

02 Silbando (C.Castillo, J.Castillo, S.Piana) Do Re Mi Fa Casa Ed. De Mus. 4:23
Osvaldo Montes / bandoneón

03 El Amanecer (R.Firpo) Ricordi Americana 2:46
TANGATA REA

04 El Choclo (A. Villoldo) 1:36
Piano melodico G. Racca (mechanical piano)

05 Ventanita de Arrabal (P.Contursi, A.Scatasso) Julio Korn Ed. Mus. 2:42
Luis Cardei / vocals, Antonio Pisano / bandoneón
Rubén Castro / guitar, Juan Carlos Gorrias / guitar

06 Anclao En Paris (E.Cadicamo, G.D.Barbieri) Garzon Editions s.a. 2:15
Luis Cardei / vocals, Rubén Castro / guitar, Juan Carlos Gorrias / guitar

07 Chiquilín de Bachin (H.Ferrer, A.Piazolla) Logos Ed. 2:56
Patricia Barone / vocals, Javier González / guitar

08 Creo en la gente (J.F.González) 3:01
JAVIER GONZÁLEZ TRIO, Patricia Barone / vocals

09 Tres esquinas (E.Cadicamo, D'Agostino) Copyright Controlled 2:31
Ernesto Maderno / vocals, Santos Tula / guitar, Lob Gimenez / guitar

10 Comme il fait (E.Arolas) 2:24
TANGATA REA

11 Derecho viejo (E.Arolas) 3:03
TANGATA REA

12 Recuerdos de Bohemia (E.P.Delfino, M. Romero) 2:33
Ricordia Ed. Americana Mus.
Osvaldo Montes / bandoneón

13 El dia que me quieras (C.Gardel, A.Le Pera) Peer Int. 4:26
CARLOS GARI & QUARTET

14 Naranjo en Flor (H.&V.Expósito) Julio Korn Ed. Mus. 3:06
CARLOS GARI & QUARTET

15 El Choclo (A.Villoldo) 1:01
Organito de la tarde (mechanical pipe organ)

16 Toda mi vida (A.Triolo, J.M.Contursi) Julio Korn Ed. Mus. 2:58
Luis Cardei / vocals, Antonio Pisano / bandoneón

17 El viejo vals (Charlo) Copyright Controlled 2:20
Claudia Acosta / vocals, Horacio Acosta / vocals & guitar

18 Como dos extranos (J.M.Contursi, P.Laurenz, M.Sosa) Julio Korn Ed. Mus. 2:49
Patricia Barone / vocals, Osvaldo Montes / bandoneón

19 Silbando (C.Castillo, J.Castillo, S.Piana) Do Re Mi Fa Casa Ed. De Mus. 1:22
Osvaldo Montes / bandoneón

CD 4

ASTOR PIAZZOLLA, Live

01 Fuga y misterio 3:38

02 Zum 5:25

03 Buenos Aires Hora Cero 5:33

04 Vardarito 6:25

05 Onda nueve 6:07

06 La muerte del Ángel 3:01

07 Tristeza de un doble "A" 7:14

08 Verano Porteño 9:12

09 Divertimento nueve 5:54

10 Preludio nueve 7:01

11 Adiós Noniño 11:30

12 Mufa 72 2:47

Music and orchestration: Astor Piazzolla

NONETO
Astor Piazzolla / bandoneón, Antonio Agri / violin, Hugo Baralis / violin, Nestor Panik / viola, José Bragato / cello, Osvaldo Tarantino / piano, Oscar Lopez Ruiz / guitar, José Correale / percussion, Kicho Diaz / bass

Recorded live in Rome 1972.
Produced by Aldo Pagani
(P) 1998 Bella Musica Edition
With kind permission of Bella Musica Edition

TANGATA REA
Lila Horovitz / double bass, Luis Longhi / bandoneón, Paulina Fain / transverse flute, Victorio Pujia / guitar, Andrés Linetzky / piano

JAVIER GONZÁLEZ TRIO
Javier González / guitar, arrangements & musical direction
Osvaldo Montes / bandoneón, Carlos Marmo / banjo

CARLOS GARI & QUARTETT
Carlos Gari / vocals, Ado Falasca / piano & musical direction, Alejandro Prevignano / bandoneón, Gerardo Pachilla / violin, Angel Bonura / double bass

Digital recording live or two track at "La Casa del Tango", "El Chino" (Bar Malena), "El Samovar de Rasputin", "El Querandi", "Mr. Master" (Andrés Mayo) and "Macrame antigüedades, "Especialistas en música Mecánica" – additional field and sound recording at "Plazoleta Dorrego" in San Telmo, at "Riachuelo" in La Boca, and various other locations in Buenos Aires, Argentina, February 8 through February 14, 1997. A Production of Winter & Winter, Producer: Stefan Winter, (P) 1997 Winter & Winter, München With kind permission of Winter & Winter, München

TANGO Index

Martina Beilharz and
Arnulf Schmidtke 2002
© Jim Zimmermann

Buenos Aires
© Oriana Eliçabe

"Balada para un loco" by
Kompania Kowski 2001

Tangoshow ca. 1995
© Jim Zimmermann

Montevideo
© Paula Oudmann

Pepito Avellaneda with
Fabiana Dragone 1993
© Jim Zimmermann

Buenos Aires
© Paula Oudmann

Pepito Avellaneda with
Claudia Rosenblatt 1993

Nestor Marconi / bandoneon
Academia del Tango
Germany 1996
© Jim Zimmermann

Buenos Aires
© Paula Oudmann

Pablo Ojeda and
Beatriz Romero 1998
© Jim Zimmermann

Buenos Aires
© Paula Oudmann

Jorge Rodriguez with Gisela
Gräf-Marino 1990*

Orchestra "Coleunes" and
Ute Frühwirth, 1995
© Jim Zimmermann

Konstantin Karamitros and
Marcella Kern 2004

Orchestra "Los Cosos de al Lao"
backstage 2002
© Jim Zimmermann

Buenos Aires
© Paula Oudmann

Jim Zimmermann and
Angelika Haigis ca. 1990
© Jens Witt

Luis Borda / solo-guitar with
Sol Bruguera / singer 1997

Angela Raith 2002
© Jim Zimmermann

Gustavo Naveira with
Claudia Rosenblatt 1991*

Boris Rodriguez Hauck,
Veronika Nadj and Udo Rabsch
© Jim Zimmermann

Boris Rodriguez Hauck and
Veronika Nadj 2001
© Jim Zimmermann

"Cambalache" with Mundo
Borgos, Fabio Block and
B.Seidel 2000

Rodolfo and Maria Cieri 1999
© Jim Zimmermann

Buenos Aires
© Oriana Eliçabe

Jorge Rodriguez with
Teresa Cunha 1996*
© Jim Zimmermann

Buenos Aires
© Oriana Eliçabe

Raul Jaurena / bandoneon and
Marga Mitchell / vocals 2002

Buenos Aires
© Paula Oudmann

Buenos Aires
© Oriana Eliçabe

Andrea Reyero and
Sebastian Missé 2003
© Jim Zimmermann

Buenos Aires
© Oriana Eliçabe

Angelika Berger and dancer
ca. 1990
© Jens Witt

Christian Riedmüller and
Renate Fischinger 2001
© Jim Zimmermann

Buenos Aires
© Paula Oudmann

Angela Raith and
Saphira Kalaitzi 2002

Ricardo Klapwijk with
Nicole Nau 1992**
© Jim Zimmermann

Gabriel Angió and
Natalia Games 1998
© Jim Zimmermann

Buenos Aires
© Paula Oudmann

Buenos Aires
© Oriana Eliçabe

Marcella Kern 2004
© Jim Zimmermann

Tangoshow ca. 1992

Katja 2001
© Jim Zimmermann

Buenos Aires
© Paula Oudmann

Milonga 2002
© Jim Zimmermann

Noel Strazza and
Sabrina Masso backstage
2002
© Jim Zimmermann

Buenos Aires
© Oriana Eliçabe

Gabriel Battaglia / guitar and
René Garcia / bandoneon
2004
© Jim Zimmermann

Buenos Aires
© Paula Oudmann

Buenos Aires
© Paula Oudmann

Tango Orchestra 1999
© Jim Zimmermann

Buenos Aires
© Oriana Eliçabe

Buenos Aires
© Paula Oudmann

Tangoshow ca. 1990
© Jim Zimmermann

Buenos Aires
© Oriana Eliçabe

Buenos Aires
© Oriana Eliçabe

Festival 1990
© Jim Zimmermann

Stefan Hiss / accordeon 2000

Claudia Codega and
Esteban Moreno 1993
© Jim Zimmermann

Claudia Codega and
Esteban Moreno 1993

Orchestra "Papirossi" 1997
© Jim Zimmermann

Buenos Aires
© Paula Oudmann

Marcella Kern 2004
© Jim Zimmermann

Chicho Frumboli with
Celine Ruiz 1999*

Chicho Frumboli with
Celine Ruiz 1999*
© Jim Zimmermann

Buenos Aires
© Paula Oudmann

Pablo Veron with
Victoria Vieyra 1998*

Milonga 2002
© Jim Zimmermann

Milonga 1995

Teté and Silvia Ceriani 1998
© Jim Zimmermann

Milonga 1998

Milonga 2000
© Jim Zimmermann

Pablo Ojeda and
Beatriz Romero 1998
© Jim Zimmermann

Buenos Aires
© Oriana Eliçabe

Buenos Aires
© Oriana Eliçabe

Ezequiel Paludi and
Sabrina Masso 2001

José Libertella at Ute Früh-
wirth´s Milonga 1989
© Jim Zimmermann

Milonga 1989

F. Ferrero / accordion
C. Amargo / bass
B. R. Hauck / violin 2001
© Jim Zimmermann

Jorge Rodriguez with
Bibiana Guilhamet 2002*
© Jim Zimmermann

Buenos Aires
© Oriana Eliçabe

Jorge Rodriguez with
Teresa Cunha 1996*
© Jim Zimmermann

Buenos Aires
© Paula Oudmann

Buenos Aires
© Paula Oudmann

Buenos Aires
© Oriana Eliçabe

Jorge Rodriguez with
Gisela Gräf-Marino 1990*
© Jim Zimmermann

Buenos Aires
© Oriana Eliçabe

Gisela Gräf-Marino
and Jorge Rodriguez 1990*
© Jim Zimmermann

*Both are working with other partners now
**Both have been working with other partners since 2002